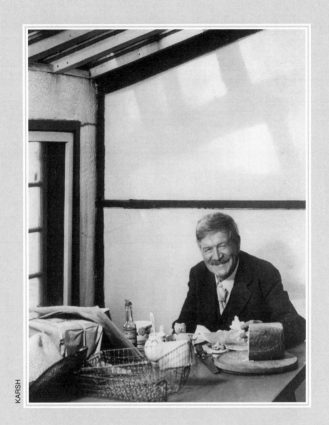

KARSH

THE STEPHEN
LEACOCK
PICTURE BOOK

JAMES A. "PETE" McGARVEY & DAPHNE MAINPRIZE

DUNDURN PRESS
TORONTO OXFORD

Editor: Barry Jowett
Design: V. John Lee
Printer: Transcontinental Printing Inc.
Back cover photographs: Pete McGarvey: Lew Taylor, Daphne Mainprize: Jamie Whibley

Canadian Cataloguing in Publication Data

McGarvey, Pete
The Stephen Leacock picture book

ISBN 1-55002-314-4
1. Leacock, Stephen, 1869–1944 — Biography. 2. Leacock, Stephen, 1869–1944 — Pictorial works.
3. Humorists, Canadian — Biography.
4. Humorists, Canadian — Pictorial works. 5. Authors, Canadian (English) — 20th century — Biography.*
6. Authors, Canadian (English) — 20th century — Pictorial works.* I. Mainprize, Daphne. II. Title

PS8523.E15Z77 1998 C818'.5209 C98-931574-6 PR9199.2.I42Z77 1998

1 2 3 4 5 02 01 00 99 98

THE CANADA COUNCIL | LE CONSEIL DES ARTS
FOR THE ARTS | DU CANADA
SINCE 1957 | DEPUIS 1957

We acknowledge the support of the Canada Council for the Arts for our publishing program. We also acknowledge the support of the Ontario Arts Council and the Book Publishing Industry Development Program of the Department of Canadian Heritage.

Printed and bound in Canada.

Printed on recycled paper.

Dundurn Press
8 Market Street
Suite 200
Toronto, Canada
M5E 1M6

Dundurn Press
73 Lime Walk
Headington, Oxford,
England
OX3 7AD

Dundurn Press
2250 Military Road
Tonawanda NY
U.S.A. 14150

CONTENTS

To Ralph Leighton Curry, Ph.D. (1924–1997)
Scholar, Gentleman, and Leacock Champion.

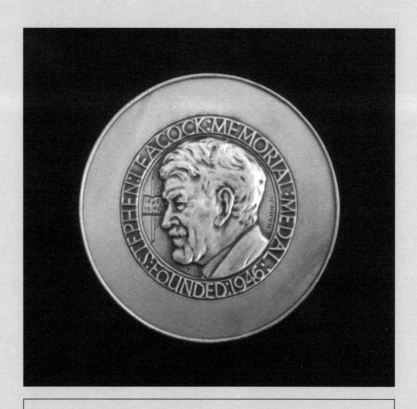

Stephen Leacock Medal for Humour —
presented annually since 1947.

INTRODUCTION

Stephen Butler Leacock was a genius of humour who looked the part. The passing years etched laughter lines ever deeper into his face and his eyes twinkled more merrily. In his 1941 reportage portraits at The Old Brewery Bay, Yousuf Karsh, another Canadian genius, captured it all — the aging face smiling over the day's output at the homemade sunporch desk; beaming over breakfast; looking pleased in the role of farmer; and happier still with a casting rod in his hand at the edge of the bay. Karsh's portraits, many reproduced in this volume, reveal a man aware of his place in the world and at peace with himself.

Earlier portraits, taken during the long years at McGill, disclose the other Leacock — scholar, teacher, lecturer, author of economic texts, histories, and biographies — clad properly in academic dignity. Though the wit was never far from the surface, as his students and colleagues attested, he kept it well hidden from the camera's lens. What we glimpse is a man of uncommon good looks and a manliness not unlike Ernest Hemingway's, complete with learned brow and an air of wisdom in all things.

Then there was the laid-back Leacock of The Old Brewery Bay, the farmer, builder, and genial host at his summer property in Orillia, acquired in 1908. Four years after his adoption of Orillia as a home town, he immortalized the place in what is arguably the most perceptive book ever written about Canada and Canadians, *Sunshine Sketches of a Little Town*. For generations, the myth has persisted that Orillians were angered by unflattering caricatures of some well-known citizens in the book. Not so. Those who appeared between the covers were openly delighted, particularly Canon Richard Greene, rector of St. James' Anglican Church, presumed to be the inspiration for the hapless Dean Drone. Those left out were miffed. It didn't matter either way. Leacock remained a proud Orillian to the end of his days, with friends in every social circle. Much of our book is devoted to the Orillia years, with generous use of the picture files maintained at the Leacock summer home, formally known as the Stephen Leacock Museum.

We are greatly indebted to Yousuf Karsh for permission to use his superb 1941 reportage series in this book. A chapter is devoted to his recorded account of his visit to The Old Brewery Bay. Unless otherwise

specified, all pictures are drawn from the Leacock Museum archives. Our gratitude as well to Kirk Howard for commissioning this book and encouraging us in its production. Special thanks go to the skilled staff of Dundurn Press for the excellence of editing, design, and photo reproduction, while working against a deadline.

This book is dedicated to the memory of Ralph Curry, the Kentuckian professor who was Stephen Leacock's first biographer (*Stephen Leacock, Humorist and Humanist*, New York: Doubleday, 1959) and first curator of the Stephen Leacock Museum, serving from 1957 to 1975. In the course of twenty summers in Orillia, he sorted, identified, and recorded some 32,000 items of Leacock memorabilia, manuscripts, letters, and photographs donated to the home by Louis B. Ruby. The resulting collection — housed in what's now known as the Dr. Ralph Curry Archival Area of Swanmore Hall — constitutes the most extensive and comprehensive collection of Leacock material in the world. Ralph Curry's short biography of Stephen Leacock is reproduced with the kind permission of Dr. Gwen Canfill Curry.

In "Three Score and Ten," an essay marking his seventieth birthday, Stephen Leacock imagined his life as a series of newsreel images flashing before his eyes; a newsreel that began in Hampshire, England, included his ocean passage to Canada, a farm in a lost corner of Ontario, boarding school days at Upper Canada College, Chicago University with its smoky pubs, then thirty-six years at McGill University. He threw in, as interludes, "journeys to England, a lecture trip around the Empire ... put in Colombo, Ceylon, for atmosphere ... then more college years." Then came retirement. He concludes, "Such is my picture, the cavalcade all the way down from the clouds of morning to the mists of the evening."

Consider this book as some freeze frames from that remarkable newsreel/cavalcade.

James A. "Pete" McGarvey
Daphne Mainprize
Orillia, October 1998.

STEPHEN BUTLER LEACOCK

BY *RALPH CURRY*

Born in "exactly the middle year of Queen Victoria's reign" (1869), Stephen Butler Leacock was both a nineteenth- and twentieth-century author.

Stephen's father, Walter Peter Leacock, tried farming at three different places before he finally gave up and turned to his natural calling — remittance man. In succession, he tried farming in Mariztburg, South Africa, in Kansas, and in Ontario. Between the first two abortive attempts, he returned to England to study farming by "drinking beer under the tutelage of Hampshire farmers who, of course, could drink more than he could." Here in Swanmore, Stephen Leacock was born on December 30, 1869.

Stephen Leacock first saw Canada in the spring of 1876 when he came to the country with the rest of the family to join his father, who had already settled on a hundred-acre farm near Sutton, Ontario. The roomy house was big enough for all eleven Leacock children, though cutting wood for the nine stoves was a time-consuming chore. The older children attended a "little red school house" near the farm until Agnes, Stephen's mother, decided the children were losing their Hampshire accents and installed a tutor in a classroom at the farm.

Young Stephen learned to fit into rural Ontario life. He did his work on the farm, but he swam in and sailed on Lake Simcoe. He played cricket at Sibbald's Point. He saw construction of the lovely little Church of St. George the Martyr finished. He watched the lake steamers handle the commerce of the region, and he saw the railroad come to Sutton and Jackson's Point, ultimately to replace those same steamers. And when he learned all his tutor had to teach him, he enrolled, with two brothers, in Upper Canada College, his first real connection with the formal education that would occupy him the rest of his life.

At Upper Canada College, young Leacock met a more sophisticated life than he had known before. Here was the life of the city. Here was the world of popular journalism, including the comic magazines, which were to play such a role in his career. Here was algebra. Here was a school paper, *The College Times*, for

which he could and did write. Stephen quickly out-distanced his brothers, who shortly left Upper Canada College; and he presently outdistanced the rest of the students, being "head boy" in 1887, the year of his graduation.

In the same year Stephen saw his father for the last time. At the age of seventeen, he was the oldest son still at home. Walter Peter had been in and out since 1876, siring children and leaving them to the care of Agnes. In 1887 Stephen could not longer accept his father's treatment of his mother. He drove his father to the train station in Sutton, put him on a train, and, brandishing the buggy whip, told him, "If you ever come back, I'll kill you!" From that day, Stephen clearly had to take a responsibility for his mother that the other children did not feel.

In the autumn, he entered the University of Toronto, where he had a very successful year. With his superior training from Upper Canada College, Leacock was granted third-year status after one year at university. But the impoverished state of his mother and younger brothers and sisters weighed on him. Deciding that he had to support himself and help support his family, he applied for teacher training and was assigned to Strathroy Collegiate Institute. He taught at Uxbridge and then went to Upper Canada College as a junior master. While teaching at the college, Stephen attended classes at the University of Toronto, taking his BA in 1891 in modern languages.

For the next eight years he doggedly taught languages, and was finally appointed senior housemaster at the age of twenty-five. Unchallenged by the job, he began to write short pieces for the comic magazines of the time, while studying political economy on his own. Thorstein Veblen's *The Theory of the Leisure Class* (1899) increased his interest. And he met Beatrix Hamilton, whom he wanted to marry. He left Upper Canada College in 1899 to study for his PhD in political economy at the University of Chicago.

By the time Leacock received his degree *magna cum laude* in 1903, he had begun to map out his future. He had married Beatrix in 1900 and he had started teaching at McGill University as a special lecturer in 1901. His students at McGill had been impressed enough to report their admiration to their principal. And his marriage to Trix, as he usually called her, had been singularly happy. When McGill offered him a full-time position, the Leacocks made a permanent move to Montreal.

In 1908, after a world tour for the Rhodes Foundation, Leacock was made head of the Department of Political Science and Economics, helped found the University Club of Montreal, and bought Old Brewery Bay — a thirty-three-acre property on Lake

Couchiching. Developing these enterprises took a large part of Leacock's energy and time the rest of his life.

He published a text in political science and other serious articles intended to enhance his professional reputation during the first part of his career. And while *Elements of Political Science* (1906) sold well, Leacock began to need more money to live the way he desired. He could not ignore that he had begun to build his small reputation as a humour writer, so he collected the fugitive pieces and submitted them to the publisher of the economic text.

His publisher turned the project down. With courage but no little trepidation, Leacock published his first book of humour himself. John Lane immediately picked it up, published an enlarged edition, and introduced Leacock to his audience with *Literary Lapses* in 1910.

In quick succession, Leacock turned out some of his most lasting works for this voracious audience. *Nonsense Novels* (1911), *Sunshine Sketches of a Little Town* (1912) *Behind the Beyond and Other Contributions to Human Knowledge* (1913) and *Arcadian Adventures of the Idle Rich* (1914). But in this last year, 1914, as if to remind himself of his scholarly stance, he wrote three volumes of history. The birth of his only son the next year perhaps strengthened a resolve to do "serious" writing. After *Moonbeams from the Larger Lunacy*, (1915)

Leacock collected some earlier popular essays into *Essays and Literary Studies*.

The mixed call to make the public laugh and make them listen continued throughout Leacock's life, but the lure of humour was stronger; in only two of the years from 1910 until his death did he not produce a humorous volume for his waiting readers.

The birth of Stephen Lushington Leacock on August 19, 1915, was a long-delayed happiness for Beatrix and Stephen and began the most fulfilling part of Leacock's private life. After World War I, the Leacocks went to England for a very successful lecture tour. *The Unsolved Riddle of Social Justice*, (1920) perhaps his most significant serious book, was well received. Book sales soared. His books during this time were generally respectable in quality and at least one, *My Discovery of England*, ranks with the best. However it was increasingly apparent that young Stephen, because of hormonal problems, was not growing as he should and early in 1925 Beatrix was diagnosed as suffering from advanced breast cancer. She died at the end of the year.

For the next ten years, Leacock gave himself more to McGill and his scholarly profession than to his comedic one, although he turned out a funny book in nearly every year. During this decade he wrote most of his biographies, much of his literary criticism, and a

number of internal contributions for McGill University, and he pushed his students harder, starting a published series for their MA theses. With the help of his niece, Barbara Nimmo, he re-established his life and routine.

Leacock, however, was shocked by notification of his forced retirement in 1936. He had turned to McGill more and more as the centre of his life, and the abrupt termination might have devastated him. Instead, it made him angry, and evidently the anger stirred the creative juices in him again. A study of humour, a book about a lecture tour through the West, more funny books (mixed now with a quieter, serious intent), and more serious books now relieved by gentle humour, poured from his prolific pen. This period produced such different books as *My Remarkable Uncle and Other Sketches* (1942), *Montreal, Seaport and City* (1942), and *How to Write* (1943).

With the outbreak of the Second World War, Leacock frequently turned his talents to patriotic causes, supporting the war effort wherever possible. He wrote for the Victory Loan drives; he wrote to encourage the United States to join with Britain and Canada, and when they did, wrote in appreciation; he wrote of the noble cause of the Allies; and he wrote on the prospects for Canada after the war. He put his automobile up on blocks, determined to use no more gasoline until after the war.

Late in 1943, Leacock began having trouble with hoarseness and difficulty in swallowing. The ailment seemed to respond to treatment at first but then grew steadily worse. When it became clear that he was suffering from cancer of the throat, the necessary operation was scheduled. Meanwhile he went on with his work, although slowly. He finished a manuscript he had under way. He sorted through his papers on February 22, 1944, and wrote a memorandum, which he laid on top of a stack of odd papers:

Sorted
All ready
None needed for —
Barbara's Book.

"Barbara's Book" was a reference to his agreement with his niece to gather his unpublished materials into a posthumous volume which she would edit. She would not need to look through this stack. On March 16, the operation was performed in Toronto, but at the age of seventy-four, his stamina depleted, he had not the strength to recover. Twelve days later, Stephen Leacock was dead.

His had been a distinguished career. He had been awarded seven honorary degrees and three medals for literary excellence. He had written sixty-one volumes

in more than a half-dozen fields, more than half in humour, of course. He had produced over ninety articles of a serious and scholarly nature. He had advised prime ministers. But mostly, he had made the world laugh. As the Christian Science Monitor said at his passing: "It is all that a man can ask that his fellows should be unable to remember him without a smile, that laughter should be the ultimate expression of their love."

(Note: this essay appeared in *Stephen Leacock and His Works*, published by ECW Press and reprinted here with permission.)

Five-year-old Stephen Leacock writes to his father —
September 25, 1875.

CHAPTER ONE:

ROOTS

Stephen Leacock was born in a red-tiled seventeenth-century cottage in the village of Swanmore, Hampshire, England, on December 30, 1869 — the penultimate day of the decade. For most of his life he insisted his birthplace was a village of the same name (Swanmore) on the Isle of Wight. The confusion was understandable. Leacock's great grandfather, John Leacock, made a fortune in the wine trade in Madeira and retired to Oak Hill, an estate near Ryde on the Isle of Wight. (Leacock Madeira is still sold throughout the world.) John's son, Walter, succeeded to the estate but Stephen's father, Walter Peter, would see little of the family fortune, except as a remittance man in South Africa, the American West, and finally rural Ontario.

Walter Peter was banished from the manor house for marrying without parental permission. On New Year's Day, 1867, the seventeen-year-old eloped to London with twenty-two-year-old Agnes Emma Butler, daughter of Reverend Stephen Butler, a distinguished clergyman in a distinguished Hampshire family. The Butlers were as much in the dark and as disappointed as the Leacocks, but both families kept up appearances. The marriage would produce eleven children. Jim, the eldest, was born in 1867 in South Africa, during the first of Peter's disastrous farming ventures. Dick followed in 1868, and Stephen in 1869, when the family was again back in England and Peter employed as an asphalt contractor in Swanmore. Four more children — Charlie, Teddy, Missie, and George — were born in England. Their younger sisters, Marjorie, Maisie, Carrie, Dot, and Daisy, were Canadian born. After yet another failed farming venture in Kansas, Peter returned to England like a bad penny. He was still not welcome at Oak Hill, and in 1876 he sailed to Canada in a third and final attempt to prove he was a man of the soil, his hopes pinned on a hundred-acre spread near Sutton on Lake Simcoe. Agnes and six children followed in the spring of 1876, aboard the S.S. *Sarmation*.

At seven years of age, Stephen Butler Leacock was introduced to the land he would cherish and enrich all his days.

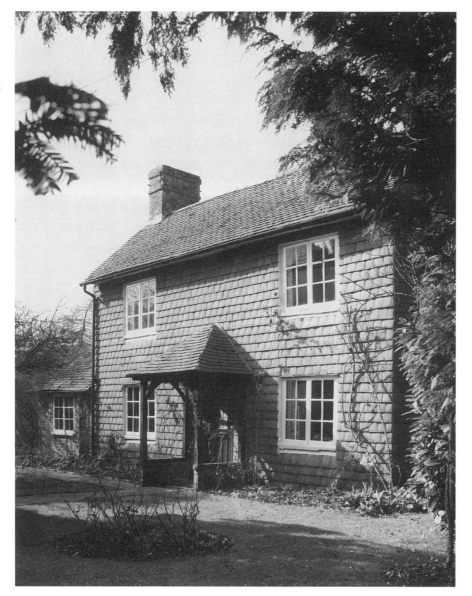

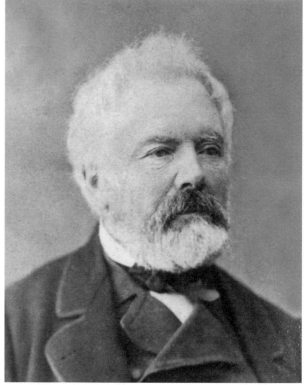

The tiled cottage in Swanmore, Hampshire, England, where Stephen Leacock was born on December 30, 1869.

Walter Murdoch Leacock, Stephen's grandfather. Heir to a wine fortune and master of an estate at Ryde, Isle of Wight, he financed farm ventures abroad for ne'er-do-well son Peter to keep him at ocean's length from the family manor.

Left: Walter Peter Leacock, Stephen's father, at Oak Hill, Isle of Wight, 1855.

Right: Stephen's father, Walter Peter Leacock, in a studio setting, c. 1866.

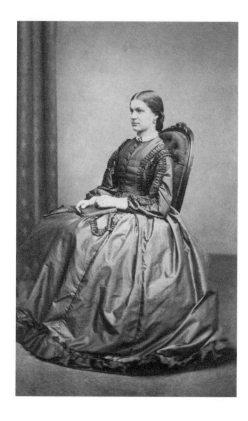

Agnes Emma Leacock, Stephen's mother, c. 1866.

The Leacock family at Ryde, Isle of Wight, 1870. Left to right: Walter Murdoch Leacock, his sons Edward Philip and Walter Peter, and Agnes Leacock, with infant Stephen in her arms. Jim (left) and Dick Leacock are in front.

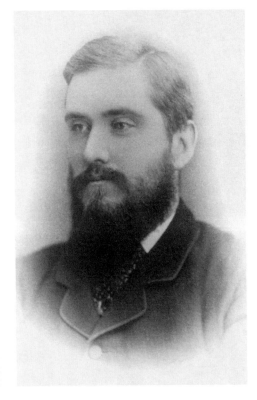

Edward Philip Leacock, Stephen Leacock's "Remarkable Uncle." A loveable con man and a Manitoba pioneeer, he was, in Stephen Leacock's own words, "President of a bank (that never opened) head of a brewery (for brewing the Red River) and above all, secretary-treasurer of the Winnipeg, Hudson Bay and Arctic Ocean Railway that had a charter authorizing it to build a road to the Arctic Ocean." Edward won election to the Manitoba Legislature in 1888 and served two years.

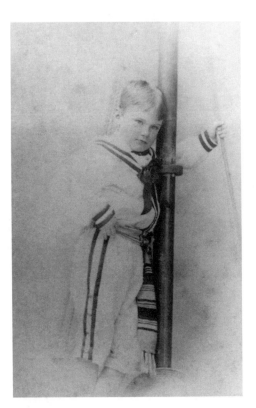

Stephen Butler Leacock, age 6, Ryde, Isle of Wight, 1876.

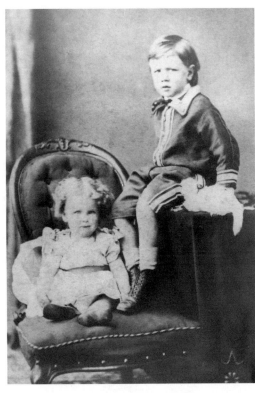

Stephen Leacock with brother Teddy (b. 1874), in Shoreham, Sussex, 1876.

My dear Dadda
I am glad Toronto
is a nice place. My
cat is grown up to be
a Mother cat and has
got 2 little kittens
your affec^te Son
Stephen

Sep^r 26^th /75

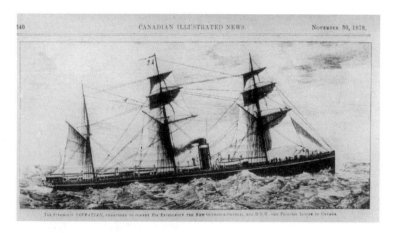

A letter to "Dada" from five-year-old Stephen, September 25, 1875.

The steamer S.S. *Sarmation*, which brought the Leacocks to Canada in 1876.

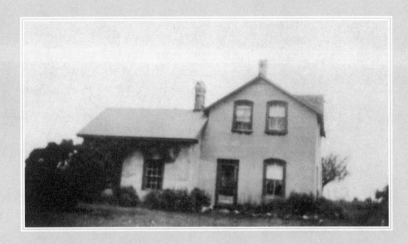

The farm home at Egypt. It was a misery of a place,
remembered by Leacock for its stench and unending toil.

CHAPTER TWO:

EGYPT TO UPPER CANADA

The Allan Line's S.S. *Sarmation*, which used both sails and steam, landed the Leacocks in Montreal in May 1876. A river steamer carried them up the St. Lawrence and into Lake Ontario, arriving at Toronto, where they boarded a train to Newmarket. Peter met them with two farm wagons for the trek to Egypt along bone-crunching forest trails. The sight of her new home broke Agnes's heart, as she confessed years later to Stephen. It was a ramshackle log structure covered with clapboard, with a cookhouse and woodshed tacked on behind. "The damndest place I ever saw," the humorist would remember. An "unspeakable" cow shed, a never-cleaned hen house, and pig sties produced a stench remembered to his dying day. New quarters added for the family within a year didn't help much, constructed as they were of frame lumber "thin as cardboard and cold as a refrigerator."

Peter grew wheat and raised livestock on his hundred acres, but rarely turned a profit. For the older children, the chores were unrelieved drudgery. Stephen's escape came through learning.

Anxious to preserve some English gentility in the Canadian bush, Agnes hired tutor Harry Park to educate her offspring at home. Park quickly recognized the brilliance of her third son, and encouraged him in mathematics, English, and history. Grandfather Walter Leacock supplied funds to send young Stephen to Upper Canada College in 1882, joining his two older brothers there. He distinguished himself swiftly as an all-around scholar and graduated in 1887 as Top Boy at age seventeen. In the same year he drove his father from the Egypt farmhouse; the misery he had caused his wife and family could no longer be borne. After a year at the University of Toronto, Stephen took up a high school teaching career to help support his mother and siblings. These were the "boarding house" days, at Strathroy and Uxbridge, recalled in later essays. In 1889, he returned to Upper Canada College as a teacher. The 1890s saw him as both teacher and student, instructing in modern languages at Upper Canada while completing studies at the University of Toronto. In 1898, he departed Toronto for courses in political economy at the University of Chicago, in preparation for what was to be the academic specialty of his teaching life.

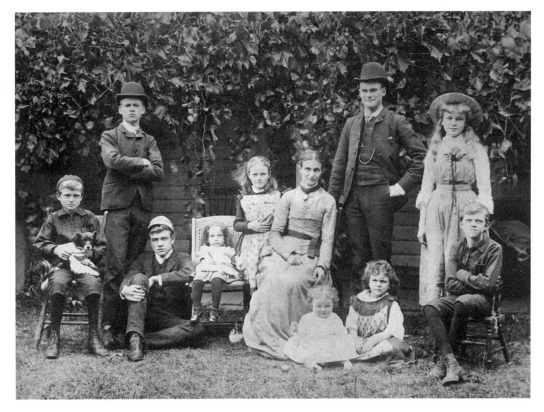

Family portrait, c. 1890. Left to right: Teddy (Edward Peter, b. January 6, 1875) with Gyp, the family pet; Charlie (Charles John Gladstone, b. December 6, 1871); Stephen (Stephen Butler b. December 30, 1869); Dot (Rosamond, b. May 28, 1884); Carrie (Caroline, b. August 10, 1878); Agnes Butler Leacock, Daisy (Margaret, b. September 10, 1886); Jim (Thomas James, b. July 24, 1867); Maymie (Maymie Douglas, b. December 24, 1880); Missie (Agnes Arabella, b. March 15, 1873); and George (b. March 1, 1877). Missing is Dick (Arthur Murdoch, b. July 1867)

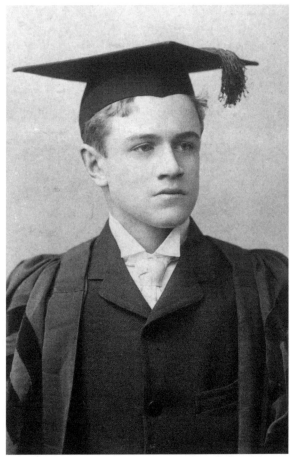

New boy at Upper Canada College, 1882.

Upper Canada College.

Report ending *Oct 13/82* of *Leacock S.B.* Form *II.* Div. *13*

ABSOLUTE RANK.	SUBJECTS.	NO. OF TIMES HEAD.	LESSONS LOST BY ABSENCE.	APPLICATION AND PROGRESS.	MASTERS' INITIALS.	PRINCIPAL'S REMARKS.
6	Scripture			good	ays	Head of Form.
1	Latin and Latin Grammar			Excellent		
5	Arithmetic			Very good		
	Algebra					
1	English Reading, &c.			Very good		
1	English Grammar and Compos'n			Excellent		
7	English Dictation			Good		
8	Modern History and Geography			very fair		
5	French			Good		
8	Writing			V fair		
	Drawing					
		Times Late	Times Detained			
	* Demerit Marks	—	1 —			

RESIDENT SCHOOL-HOUSE REPORT.

APPLICATION. { *generally good.* — *ays*

CONDUCT. { *Good —*

He Ranks No. in a Form of Pupils.

He Ranks No. in a Form of Pupils in Spring Examinations.

Please to examine carefully the above Report, compare it with the preceding (if any), and the notice to Parents and Guardians on the previous page.

N. B.—This Report to be carefully preserved by the Parent or Guardian. The Duplicate is kept by the Pupil.

* Many Pupils pass through College without ever incurring a Demerit Mark or being once detained.

October 1887 — Æt. 17.

Dixon COR. KING AND YONGE STS.
Toronto.

Above: Top Boy, graduate of Upper Canada College, October 17, 1887. Enscribed by Leacock.

Left: Report on Stephen Leacock's first term at Upper Canada College.

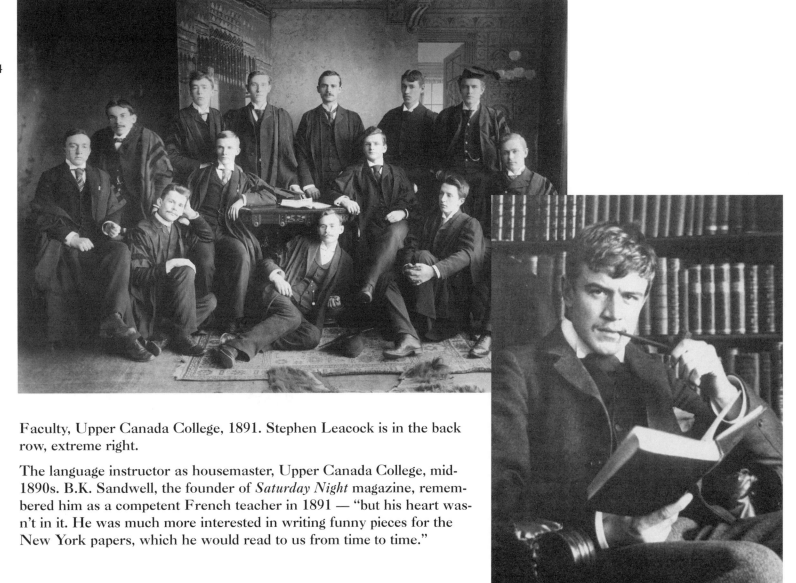

Faculty, Upper Canada College, 1891. Stephen Leacock is in the back row, extreme right.

The language instructor as housemaster, Upper Canada College, mid-1890s. B.K. Sandwell, the founder of *Saturday Night* magazine, remembered him as a competent French teacher in 1891 — "but his heart wasn't in it. He was much more interested in writing funny pieces for the New York papers, which he would read to us from time to time."

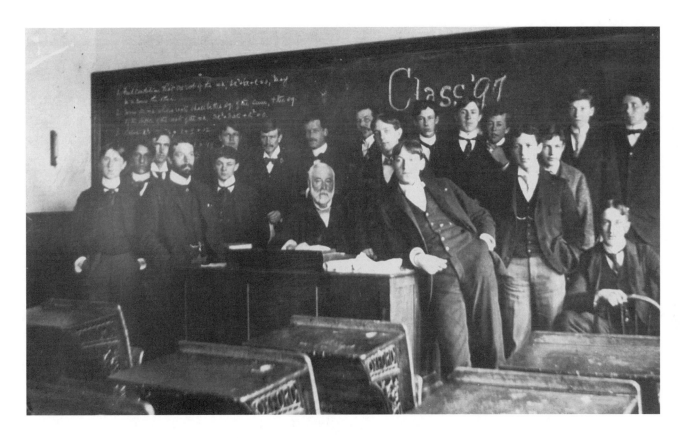

Upper Canada College faculty, 1897. Stephen Leacock back row, third from left, now sporting the moustache that would be a distinguishing characteristic for the remainder of his life.

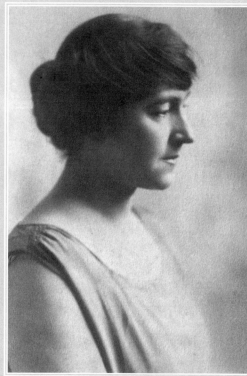

Beatrix ("Trix") Hamilton, Stephen
Leacock's bride, in 1900. Trix was an
actress, and their marriage occurred at
the "Little Church around the Corner"
near Broadway's Great White Way.

McGILL AND MARIPOSA

The twentieth century dawned bright for Stephen Butler Leacock. In 1900 he married Beatrix Hamilton, became a special lecturer at McGill University in Montreal in 1901, and the following year received his doctorate in Political Economy *summa cum laude* from the University of Chicago. Marital happiness was accompanied by academic success. In 1906, he published *Elements of Political Science*. The following year he toured the British Empire as a Rhodes Lecturer. In 1908, he was appointed head of McGill's Department of Political Science and Economics, helped found the University Club of Montreal, and purchased a 33-acre property on the south shore of Lake Couchiching. "Developing these enterprises," writes Ralph Curry, "took a large part of Leacock's energy and time the rest of his life."

In thirty-six years at McGill he enjoyed a legendary career. He was a professor remembered by generations of students for his provocative and witty lectures and his tattered academic gown. In his adopted town of Orillia, forty miles northwest of Sutton, he was proud to call himself a farmer — on a "farm" that required none

of the drudgery of the Egypt operation to maintain. Beginning with a cookhouse on the shore of what was known as The Old Brewery Bay ("a name that could rouse a thirst as far away as Nevada"), Stephen built, rebuilt, tore down, and renovated. In the early years there was a low flat summer cottage on the shore — with new rooms added as needed — an ice house, barns, and woodsheds.

Long before the 1908 property purchase, Stephen and Trix were both well established in Orillia. Agnes Leacock and her younger children had resided there since 1895. Stephen had a wide circle of friends, and was a star of the local cricket club and an enthusiastic sailor on Lake Couchiching. Meanwhile, before her marriage, Beatrix spent her summers at her uncle's estate on the Lake Couchiching shore.

To augment his modest salary as a university professor, Stephen dusted off some comic pieces written over a decade, publishing them in 1910 under the title *Literary Lapses*. The Lapses begin with the best-known of all Leacock pieces, "My Financial Career." The response was immediate and overwhelming from both

public and critics. The possibility of an alternate — or parallel — career as a popular humorist unfolded before him.

He opted for "parallel." Over the next three decades his books of humour set the whole world laughing, while his teaching career flourished.

Stephen Leacock's third book of humour in as many years, *Sunshine Sketches of a Little Town* (1912), was an acknowledged masterpiece. In chronicling the misadventures of some small-town Ontario movers and shakers (while writing as one of them), Leacock claimed to be describing sixty or seventy little towns. Orillians weren't fooled. They recognized their landmarks, local characters, and lore and most were pleased as punch to be known as the real Mariposans of Leacock's comic classic.

The Leacocks greeted the arrival of their only son, Stephen Lushington Leacock, on August 19, 1915, with unconfined joy. He was the centre of their lives in both Montreal and Orillia and the subject of scores of photographs.

The years rolled by with more bestselling books, more gatherings of family and friends at the Leacock cottage, more sailing and fishing, and more building. The Muskoka-style boathouse, built in 1919, was meant for an overflow of guests, but also served as Stephen's ivory tower. He would arrive at his second-floor desk at five a.m., with a pot of strong tea and his pen. By breakfast time, his daily quota of 1500 words would be completed, ready to read to whoever happened to be in residence. Leacock would laugh louder and longer than anyone else at his own prose. With a growing bank account from royalties, Stephen felt it was time for a summer home more fitting to his fortune and status: not the lakeshore built-on that had grown like Topsy; nor even the two-storey extension completed in 1916. He began to picture a dream home, but a decade would pass before that dream unfolded.

Orillia Cricket Club, 1902. Leacock is second from left, back row.

A letter from the Leacocks in Montreal to Canon Richard Greene of St. James' Anglican Church, in appreciation for paintings commissioned by the professor. Greene was a gifted painter and carver who gave Group of Seven artist Franklin Carmichael his first lessons. The same Canon Greene is assumed to be the model for Dean Drone in *Sunshine Sketches*, a portrayal Stephen's mother deplored, though the good clergyman himself was not offended.

Montreal Oct 19 1905

My dear Canon Green

We are simply delighted with the pictures, all of which are to go in our drawing room as my wife says they are much too good for my study. Beatrix is enchanted with the marine picture: we have taken it at once to be framed by Morgan & Co and they are putting on it a very wide

plain black frame with gilt rim between the frame and the picture and no mat: They said a mat would be a mistake. We went there because there is a man there who really knows pictures and on whose taste we can rely. This first picture is to be ready on Saturday and if we like it I shall at once send the others to the same place.

I really cannot express to you how pleased

admirable. I hope that you are in Montreal this winter you will come to see us and be able to judge how the pictures look when framed.

Yours very sincerely

Stephen Leacock

Family group at the cook-house, the first of the buildings on Leacock's summer property, c. 1909. Stephen is in the wheelbarrow.

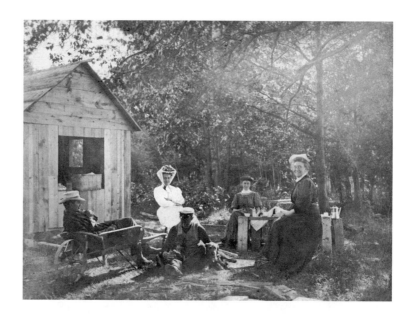

Jackson Brewery flourished on the lakeshore in the 1880s. By the time Leacock bought his property in 1908, it lay in ruins, but had given a name, "the old brewery," to the bay.

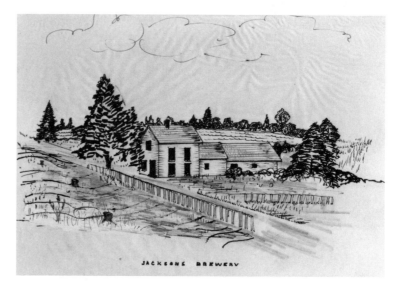

Sunshine Sketches of a Little Town, a chapter heading from a book that would immortalize Orillia. The original manuscript was donated to the Stephen Leacock Museum in 1966.

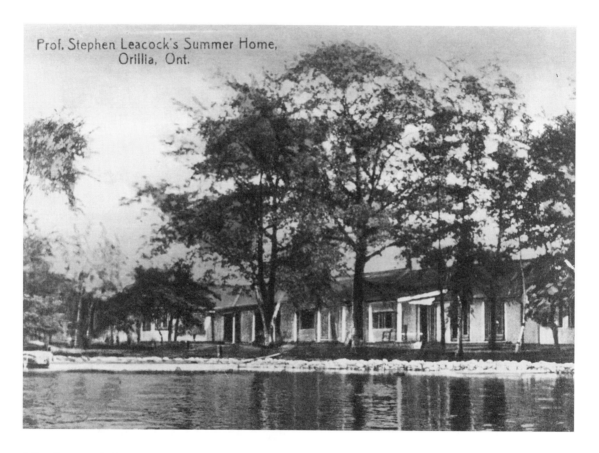

The Leacocks' lakeshore cottage, c. 1910.

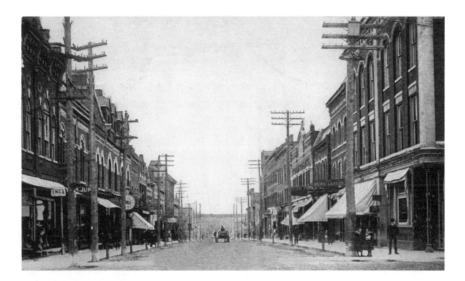

Mississaga Street, Orillia, c. 33
1910. The wide thoroughfare
would be known as
Missinabi Street in *Sunshine
Sketches of a Little Town*.

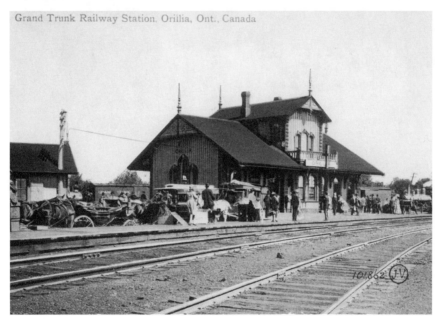

Grand Trunk Railway Station, Orillia, Ont., Canada

The Grand Trunk, Orillia,
where "the train to
Mariposa" pulled in every
evening.

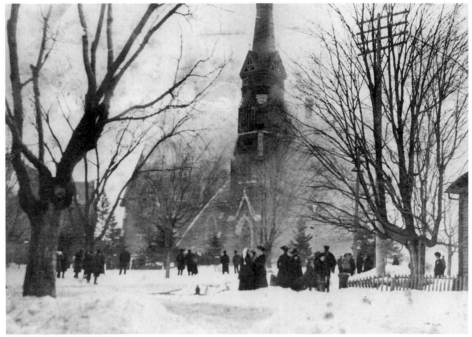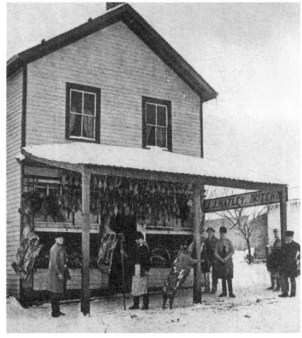

The fire at St. James' Anglican Church in 1895 inspired "The Beacon on the Hill" in *Sunshine Sketches*. In the *Sketches*, the church fire was a means of paying off the mortgage. In real life there was no such skullduggery: the fire was purely accidental.

Hatley's Store, c. 1890. Identified as "Netley's" in *Sunshine Sketches*.

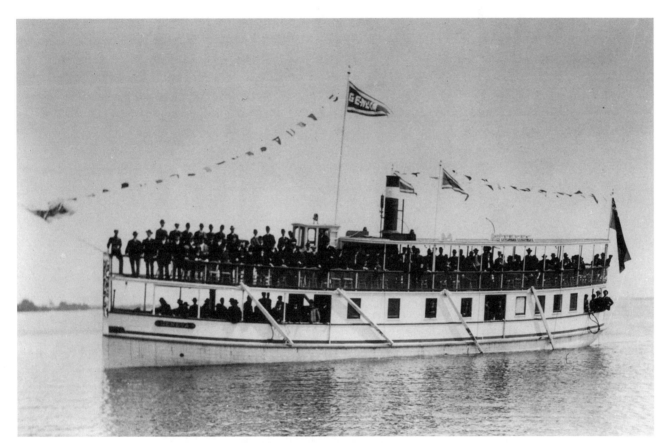

The steamer *Geneva* was one of several lakecraft that served as the model for *The Mariposa Belle*. The foundering of one of them at the Narrows early in the century provided the storyline for "The Marine Excursions of the Knights of Pythias," wherein hotelkeeper Josh Smith saves all hands.

36 Proud parents Stephen and Trix pose with young Steve at the Cote-des-Neiges house in Montreal, c. May 1915.

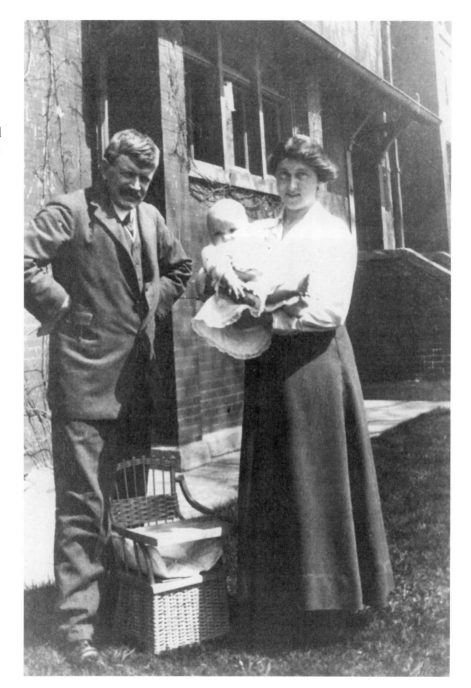

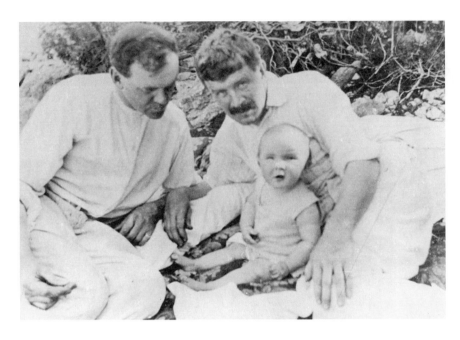

Brother George with Stephen and young Stevie, Orillia, 1915.

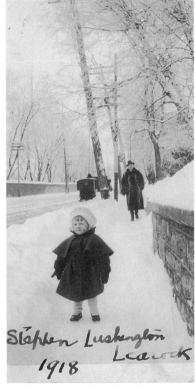

Stephen Lushington Leacock on Cote-des-Neiges, Montreal, 1918. (Picture enscribed by his father.)

Leacock's Cottage August 1916

Cottage construction, 1916.

Group on the deck at the Leacock cottage, 1918.
Left to right: Stephen, Henry Pellatt, Trix, and Mrs. May Shaw with Stevie on her knee. The Shaws and Leacocks were neighbours in both Montreal and Orillia.

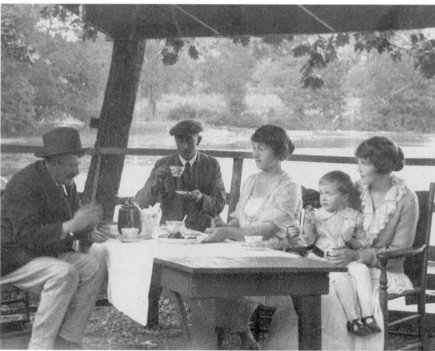

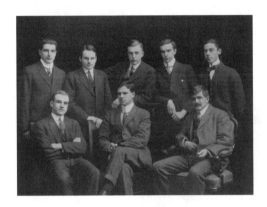

McGill Literary and Debating Society, 1915. Professor Leacock, lower right.

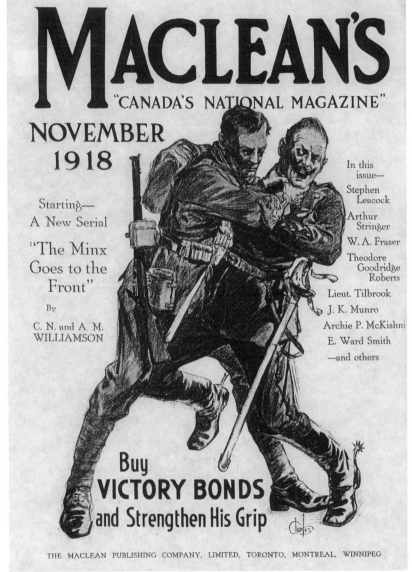

The cover of *Maclean's* magazine, November 1918. Leacock's essays, both funny and serious, were getting wide circulation in magazines and periodicals by the end of World War I.

The boathouse, constructed in 1919. Leacock's ivory tower was on the second floor. He turned out his 1500 words a day on a homemade desk facing the bay through open windows.

58 Romney St
London
Oct 20 '21

Dear mother

The enclosed is a little bit of English Holly that I cut in a lane in Derbyshire. I have been lecturing every night: lately in London: big crowds everywhere. I lectured at Rugby School + saw

Cecil's son John Butler Parry, but I think I told you that already. I expect to see Rosamond Hill at Manchester. Hester Butler turned up at this house yesterday. Stevie is very well but I don't think that it agrees with him as he can't get any decent outside play. I told you that I saw Aunt

Fanny + Carrie a little while ago. We've had our pictures in all the big illustrated papers. Steve takes it quite for granted. Yesterday I lectured at Eastbourne in Sussex the nearest I shall get to

Hampshire on my trip; intend for my purpose.

Your affectionate
Stephen Leacock

A Letter to Mother, dated London, October 21, 1921. Greatly devoted to his mother, Stephen wrote weekly from whatever part of the world he was in, but, oddly, signed every letter formally — "Your Affectionate Stephen Leacock."

General Sir Arthur Currie, hero of Vimy Ridge, principal of McGill University 1920–1933, and Leacock's close friend.

Leacock caricature, artist unknown, McGill, 1920s.

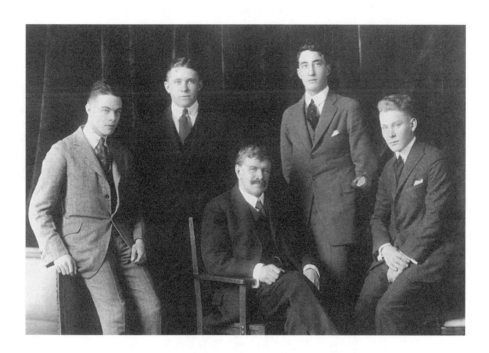

Political Economy Club, McGill, 1920. Professor Leacock seated.

Stephen, warmly clad, with
Stevie and neighbour
Peggy Shaw, at Orillia, c.
1925.

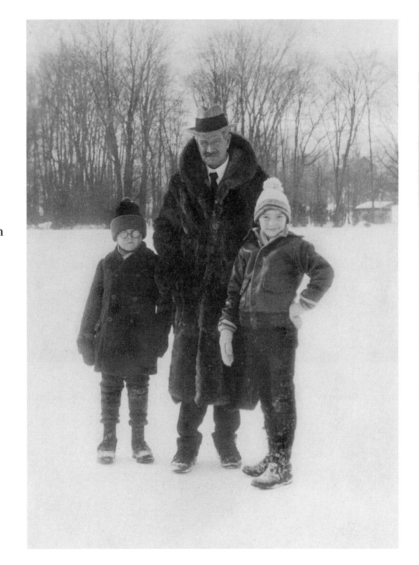

Trix on the sunporch at the
Leacock cottage, summer
1925. She would succumb
to breast cancer later that
year.

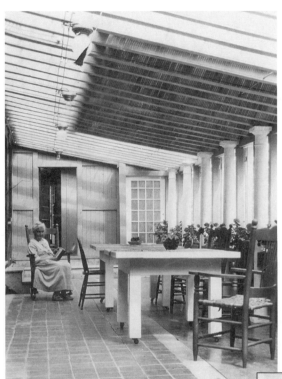

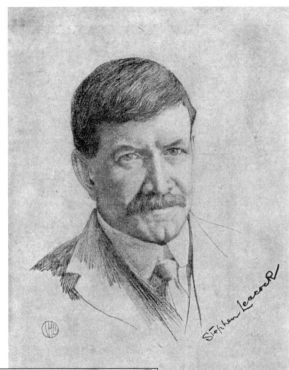

Sketch of Stephen
Leacock, Vernon Hill,
1920s.

Agnes Leacock on the sun-
porch, 1925.

Trix with Stevie,
Atlantic City,
1921.

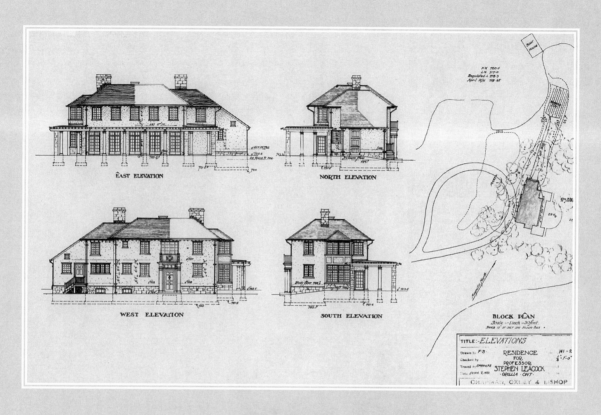

Elaborate plans for a chateau, 1926, from architects Chapman, Oxley, and Bishop.

CHAPTER FOUR:

THE OLD BREWERY BAY

The loss to breast cancer of his beloved Trix at the close of 1925 left Stephen Leacock devastated. Work became his grief therapy. He plunged into new writing ventures and revived plans for an enlarged summer home in Orillia. Young Stevie became central to his life. Hormonal problems had stunted his normal growth; the best doctors available were consulted, but to little avail.

Stevie would remain short in stature all his life. As for the summer house, Leacock wanted something impressive. The Toronto firm of Chapman, Oxley, and Bishop supplied just that in a set of 1926 blueprints of a fancy French chateau facing Barnfield Bay. The place did justice to Leacock's stature, but the cost — $20,000 — floored him. He had planned to spend no more than $8,000!

The following year, after a trip to Biarritz for Stevie's benefit, Leacock called Kenneth Noxon of the Toronto firm of Wright and Noxon, outlining the kind of place he had in mind. To Noxon, it was a dream assignment. In sketches forwarded to Montreal through the winter, he proposed a two-storey stuccoed residence on a rise 170 feet back from the lake; a symmetrical design featuring a living room, dining room, library, two

bedrooms, a sunporch, servants quarters, a kitchen and larder on the first floor, and four spacious bedrooms on the second, each with a balcony. Leacock rained praise on the youthful architect for his inspired design. By using materials from the older cottage and extensions, the cost of the new home was reduced to less than $17,500.

Leacock's long-awaited dream home was constructed in record time in the spring of 1928 and immediately became a rendezvous for entertaining, a place for share with his mother, brothers, and sisters, a venue for entertaining, and a working farm, with orchards, gardens, poultry, and an occasional horse. Leacock was in his glory. He called the place "The Old Brewery Bay."

The summer season began early here. As soon as his McGill schedule allowed, Leacock would make the springtime trek from Montreal to Orillia by motorcade, hauling in needed supplies, a housekeeping staff, and his niece, Barbara Ulrichsen, who had served as his secretary and chatelaine since Trix's death. Days began with writing in the boathouse — a new book, a commissioned article, a speech to be delivered. After this, the "serious" business of the day could begin — a fishing

expedition, work in the garden, a picnic with Stevie, nephews, and nieces. He wrote plays for Stevie and his friends, staging them in the alcove of the living room or on the front verandah. Greats of the academic and political world made the pilgrimage to The Old Brewery Bay and honours flowed in. In 1935 Leacock was guest speaker at the Mark Twain Centenary celebration in St. Louis, Missouri, and was presented with the Centenary medal by Cyril Clemens, Mark Twain's son.

The great humorist's academic career ended on a bitter note in 1936, when, at age 65, he was forced to retire from McGill University. It was a policy he had agreed to many years earlier, scarcely thinking it would apply to himself. He expressed his sentiments in a cartoon, "The McGillotine," that mentioned four fellow victims but not himself. Leacock had no intention of "retiring." Books and articles continued to flow from his talented pen, and the good life continued at The Old Brewery Bay.

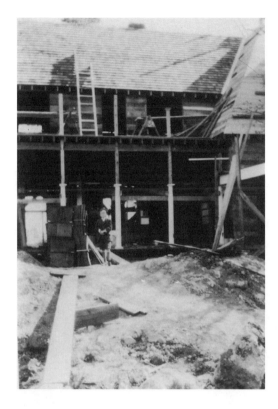

Below: Leacock's dream home, "The Old Brewery Bay," completed in the summer of 1928.

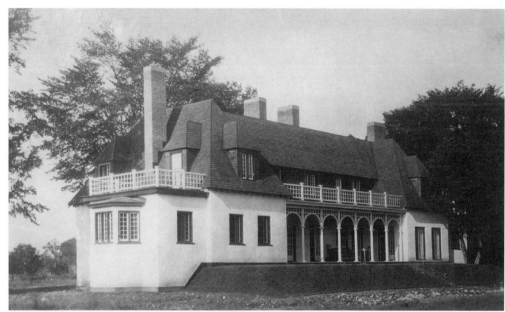

Above: "The Old Brewery Bay," designed by Kenneth Noxon, under construction in May 1928. Young Stevie poses at the west end of the verandah.

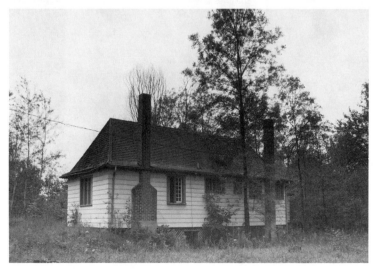

Left: The lodge, added to the estate in 1930, was another Kenneth Noxon design.

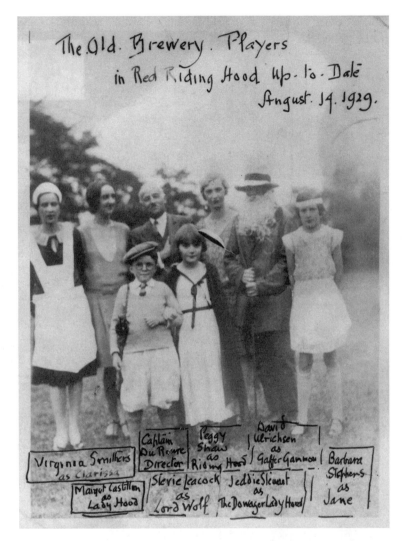

The Old Brewery Players, 1929 (identified in Leacock's handwriting).

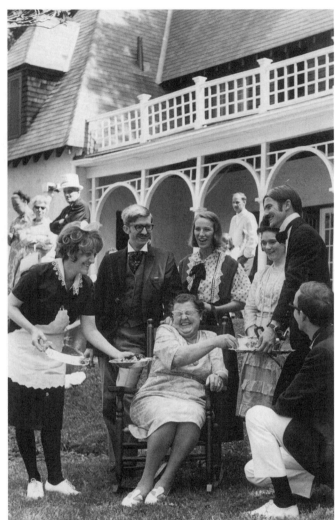

A tradition continues: a Leacock play on the lawn at The Old Brewery Bay, mid 1970s.

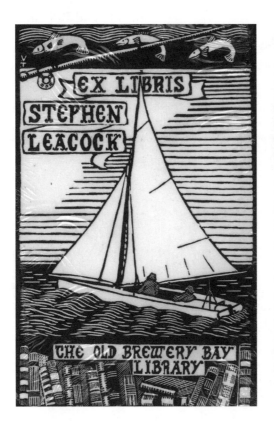

Ex Libris, Stephen Leacock,
The Old Brewery Bay Library.

Passport photo, c. 1930.

Letter, Cyril Clemens, son of Mark Twain, inviting Leacock to speak at the Mark Twain Centenary celebration, December 3, 1935, in St. Louis, Missouri.

An ad for the Mark Twain Centenary, re Cyril Clemens' speech.

CYRIL CLEMENS
INTERNATIONAL MARK TWAIN SOCIETY
WEBSTER GROVES, MISSOURI

Nov. 14. 1935

Dear Mr Leacock:—

You are most cordially invited to be the principal speaker at the grand Mark Twain Centenary Banquet that will be held in St. Louis Tuesday December 3rd, at the Jefferson Hotel. We sincerely hope that you will be able to be with us on this festive occasion.

With all good wishes,

Cyril Clemens

P. T. O

54

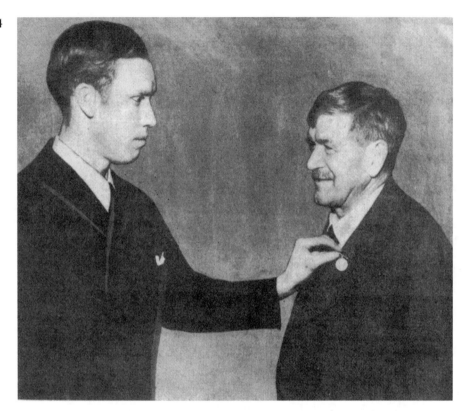

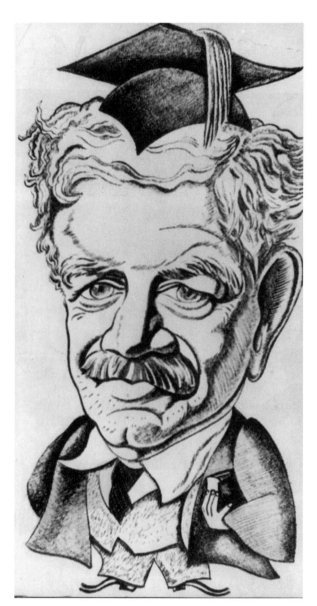

Cyril Clemens presents the Centennial medal to Stephen Leacock, December 3, 1935.

Caricature, artist unknown, 1930s.

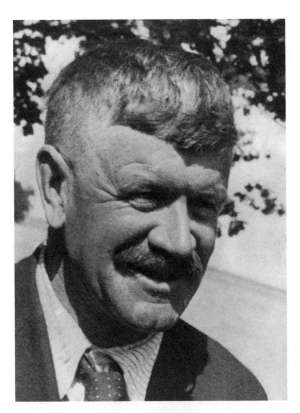

An informal photo, The Old Brewery
Bay, 1930s, shows Stephen Leacock with
a fresh and generous haircut.

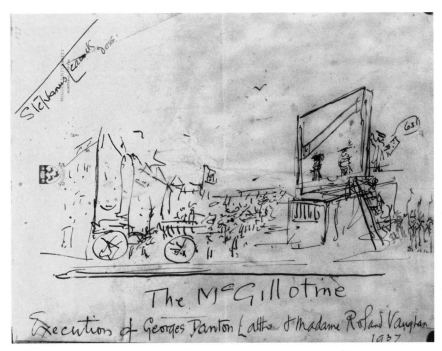

"The McGillotine," Leacock's cartoon bewailing the forced early
retirement of some colleagues. He neglected to add his own name.

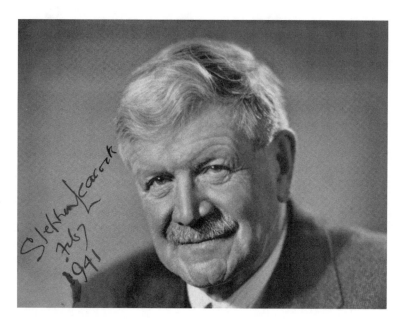

Signed picture, 1941.

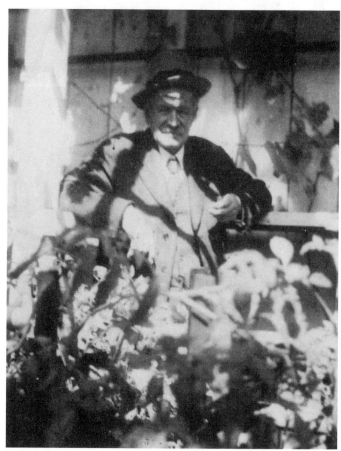

Resting at The Old Brewery Bay, 1940.

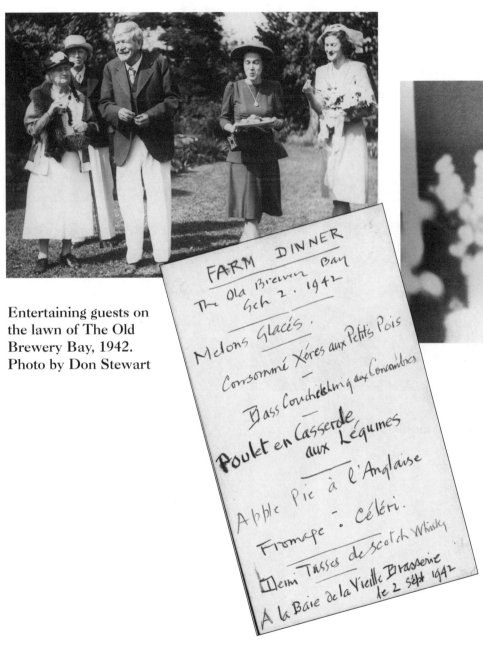

Entertaining guests on the lawn of The Old Brewery Bay, 1942. Photo by Don Stewart

FARM DINNER
The Old Brewery Bay
Sep 2. 1942

Melons Glacés.

Consommé Xéres aux Petits Pois
—
Bass Couchich'ng aux Concombres
—
Poulet en Casserole
aux Légumes

Apple Pie à l'Anglaise

Fromage · Céléri.

Demi Tasses de Scotch Whisky

A la Baie de la Vieille Brasserie
le 2 Sept 1942

Toast to the bride, May 30, 1942. The bride was next-door-neighbour Peggy Shaw, and the reception was held under canvas at The Old Brewery Bay.

A farm dinner, "a la baie de la veille brasserie" (The Old Brewery Bay), September 2, 1942. Leacock loved to stage dinners and entertainments, penning his own invitations. The farm dinner was one of the last social events at his beloved summer home.

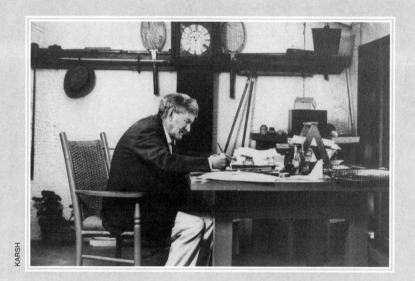

KARSH

The humorist at work at his sunporch table.

CHAPTER FIVE:

KARSH COMES CALLING

One spring day in 1941, Canadian portrait photographer Yousuf Karsh gained world fame with a single shot. He snatched a cigar from the fingers of Winston Churchill just before closing the shutter. The resulting portrait, Churchill scowling in annoyance, became the definitive picture of the resolute British wartime prime minister — capturing perfectly a look of bulldog resolution. Later that year, Karsh captured another famous subject in a set of definitive portraits. He travelled from Ottawa to Orillia to photograph Stephen Leacock in some unforgettable poses — as writer, farmer, fisherman, sailor, and devoted great uncle to the two-year-old daughter of Barbara Nimmo. On February 17, 1992, Karsh, then 85, discussed the experience with Pete McGarvey in Ottawa in a taped interview.

Well, I knew a good deal about Stephen Leacock through my friend, B.K. Sandwell, editor of *Saturday Night*, a philosopher, a humanitarian, and a remarkable human being. He arranged for me to meet his good friend, Stephen Leacock. Of course, I had read some of Leacock's inspired wit, which is typical of me before I meet any man I'm about to photograph. For the first time in my career, I did reportage photography; in other words I recorded this great humorist in many attitudes — having his breakfast, tending his garden, going out fishing, and all that. Instead of spending what I had expected — a day or a half a day — we ended up spending two to three days. It was all very rewarding because he was all wit and humour. He would get up in the morning and after having a simple breakfast, he would assure me he had written 1500 literary words that very day, and he would get his son, Stephen, who was teaching at that time, to read his 1500 words aloud. Stephen Jr. was so much in awe of his gifted father that he did not read it quite well. But with a certain amount of humour, he cajoled his father about not being able to read his handwriting. He was a co-operative subject. He would feel a certain relief after the morning writing and could enjoy himself. The portrait of Leacock at his writing table in the sunporch is the essence of the man because he's jovial, he's fulfilled; he seems to be intellectual as well as casual, seated at his desk soon after breakfast. He would discuss almost any subject. I ended up sending him a large print of that portrait soon after I returned to Ottawa from our session in Orillia. He sent me a note, giving me

the Gold Medal of Stephen Leacock, which was non-existent; that's how appreciative he was of that portrait.

There was some wine in the cellar, so we started drinking it early in the afternoon. But after two or three days there was no wine left, so I asked Andre Gauthier to go to Barrie for more. (There was no prohibition in Barrie, but there was in Orillia.) Meantime, we had gone fishing. I immediately saw a motorboat and a canoe and jumped into the motorboat. Leacock said "No, no, Karsh. The motorboat always gets there." Then it came time to say farewell, but we pretty well did justice to the new wine before we left Orillia.

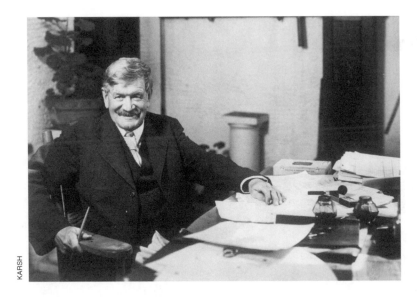

KARSH

The portrait that won the non-existent Gold Medal of Stephen Leacock for the photographer. His subject was, in Karsh's words, jovial and fulfilled, intellectual but still casual.

A bemused Stephen Leacock at breakfast on the sun-porch.

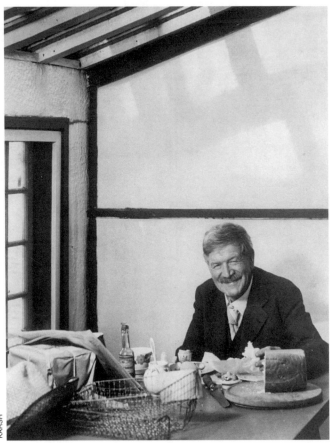

KARSH

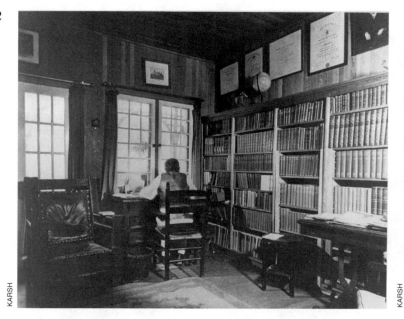

KARSH

Hard at work in the
library, filling his quota of
1500 literary words a day.

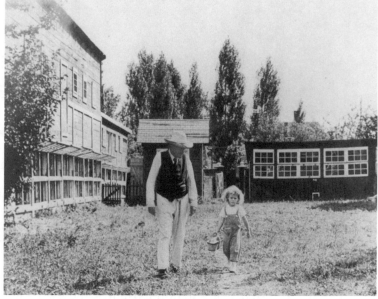

KARSH

In the barnyard with two-
year-old Nancy Nimmo, a
grandniece.

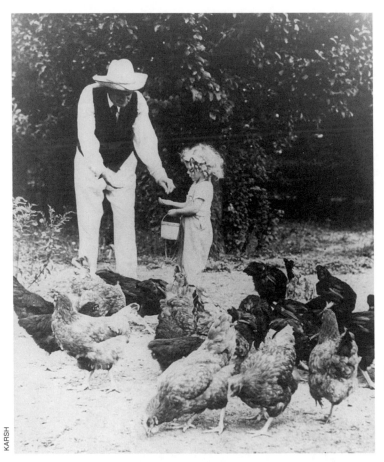

Nancy and Uncle Stephen feed the chickens.

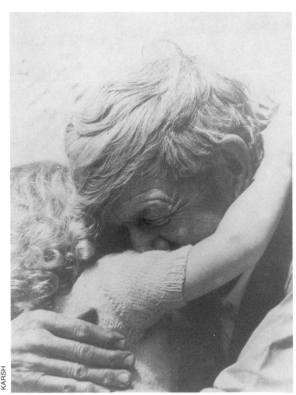

A fond embrace: Stephen Leacock and grandniece Nancy Nimmo, captured by the master photographer.

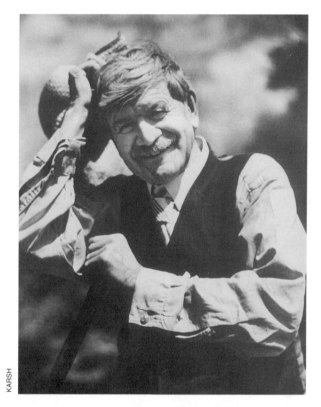

KARSH

The man of the soil at The Old Brewery Bay.

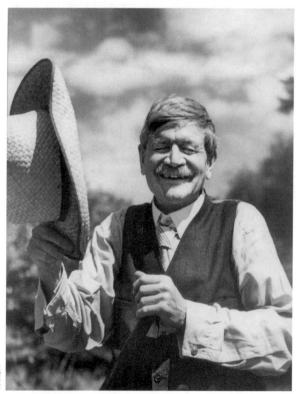

KARSH

Stephen Leacock, farmer.

Leacock posing in his gaff-
rigged yawl.

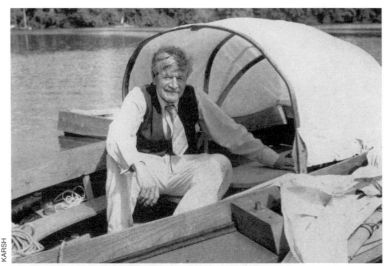

65

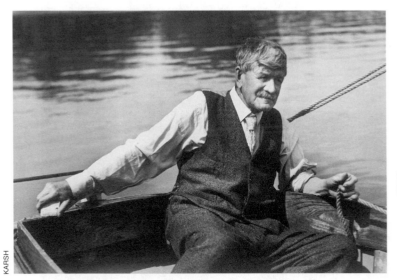

Sailing was a life-long passion for Leacock.

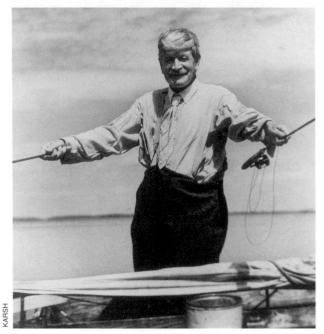

Casting into The Old Brewery Bay.

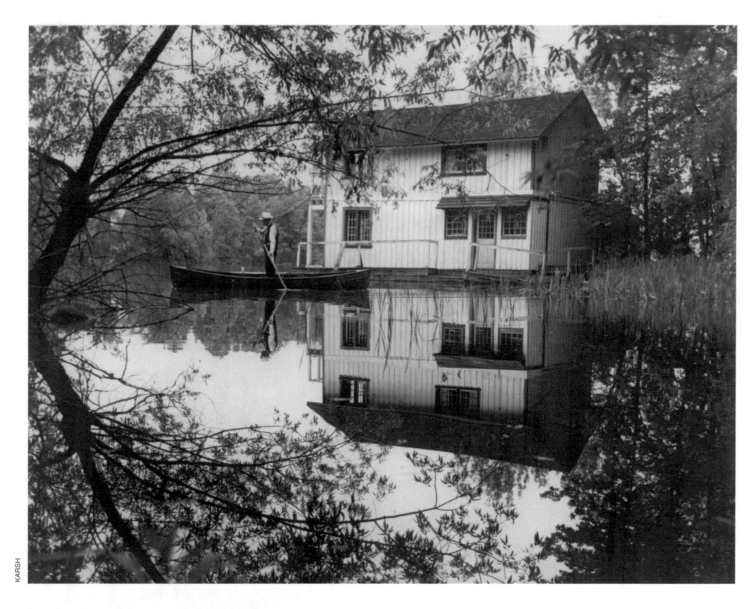

Stephen Leacock near his 1919 boathouse.

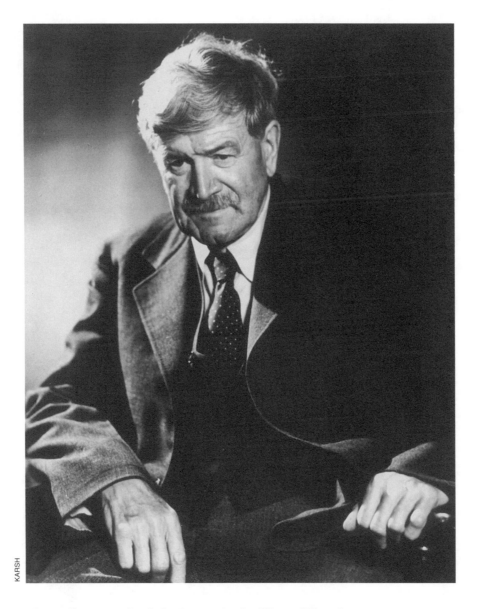

KARSH

A studio portrait of the humorist by Yousuf Karsh.

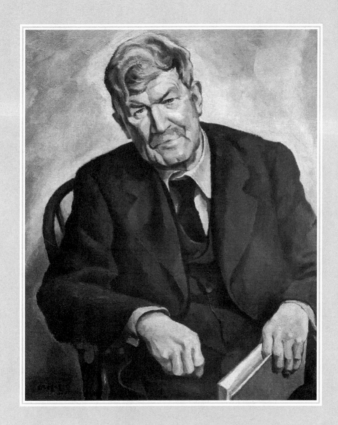

Portrait of Stephen Leacock
by Edwin H. Holgate.

THE LEGACY

Within days of the death of Stephen Leacock on March 28, 1944, Charles Harold Hale, editor of the *Orillia Packet and Times* and Leacock's friend for a half century, convened a meeting to consider some appropriate memorials. The Stephen Leacock Memorial Committee, as it styled itself, decided on three: the Stephen Leacock Medal for Humour, to be awarded annually to the author of an outstanding book of Canadian humour; a bronze bust, to be executed by Elizabeth Wyn Wood, a famed Canadian sculptor with Orillia roots; and the assemblage of Leacock first editions and other memorabilia at the Orillia Public Library. Hale, whose earlier crusades had resulted in the Champlain Monument and Orillia Soldiers Memorial Hospital, worked tirelessly. Letters went to leaders of the literary community (who immediately pledged support), former Leacock students now prominent in politics and business, and philanthropists who believed in preserving Canada's heritage. The first Leacock Medal for Humour was awarded June 13, 1947, to Harry Symons, author of *Ojibway Melody*. The occasion was an Orillia banquet of high humour and spoofery that set a pattern followed for more than fifty

years! In 1951 the Leacock Memorial Committee became the Leacock Associates, and as such have continued to host the annual medal dinner and a celebration of Leacock's birthday every December 30th, year after year.

The commissioned Stephen Leacock bust was unveiled in September 1951 at the Orillia library in a ceremony attended by Stephen Leacock's brother George and Orillia-born Premier Leslie M. Frost. The Leacock book and memorabilia collection also proceeded, but more urgent business beckoned. Ten years after the humorist's death, his summer property was listed for sale. Again, C.H. Hale led the way, convening a citizens' meeting to find ways and means of buying and restoring The Old Brewery Bay. It was my fate to be chosen chairman of the committee; for the next four years we struggled with real estate agents, lawyers, and a reluctant town council to achieve our goal, but in the end won through. (For further details, see *The Old Brewery Bay: A Leacockian Tale*, Dundurn Press, 1994.) Town council purchased the home and an adjoining acre of property from Toronto publisher Louis Ruby for $25,000 in March 1957. A $15,000 federal grant made

extensive restoration possible. The doors of the Stephen Leacock Memorial Home were opened with a golden key on July 5, 1958. The following year, the *Toronto Telegram* raised over $7000 for the restoration of the sunporch.

Dr. Ralph Curry, a genial young English professor from Georgetown, Kentucky, author of the first Leacock biography, was named curator-director in 1957. Under his inspired governance over the next two decades, The Old Brewery Bay attracted Leacock devotees from every part of the world. He was succeeded in 1975 by Jay Cody, a noted Orillia businessman and historian, who was succeeded in turn in 1993 by Daphne Mainprize, another Orillian and fervent Leacock enthusiast. Swanmore Hall, a complex complimenting the architecture of the home, was constructed in 1993 through grants from Jobs Ontario and the Versa Care corporation. The Leacock archives are housed here. A large dining/reception hall and a gift shop complete the structure. In June 1994, The Old Brewery Bay was declared a National Historic Site in an on-site ceremony presided over by Professor Tom Symons, chairman of the National Historic Sites and Monuments Board and the son of the first Leacock medal winner, Harry Symons.

When hundreds of Orillians turned up as volunteer carpenters and painters to reconstruct the Leacock boathouse on a September weekend in 1996, it caught the attention and admiration of the entire country. The project was the brainchild of Orillians Jim Dykes, and Jim Storey, who devoted hundreds of hours to design and planning, scrounging materials, and recruiting professionals who would forego fees.

In 1997, the museum board created a task force, composed of Donald Lander, the former CEO of Canada Post, retired Orillia businessman Joe Francoz, and curator-director Daphne Mainprize to plot the future of the museum. Their strategic plan, "2000 and Beyond," projects the Leacock legacy from a local to a national and international context, with support flowing from both public and corporate donors. A $666,000 Millennium Fund contribution towards the project was announced November 2, 1998, by Simcoe North MP Paul Devillers at a Swanmore Hall ceremony, followed days later by an announcement by the Hon. Andy Mitchell, Minister for Parks, of a generous Parks Canada cost-sharing contribution.

We think Stephen Leacock would be pleased by these developments and the devotion and care provided his beloved summer home over many years by many people. Since his death in 1944, pilgrims in their thousands have caught the spirit of the man and the place in a leisurely exploration of his home and restored boathouse and contemplative moments on the lakeshore.

"I shall not altogether die," he once said. Nor will he, as long as laughter lingers and the relics of his life

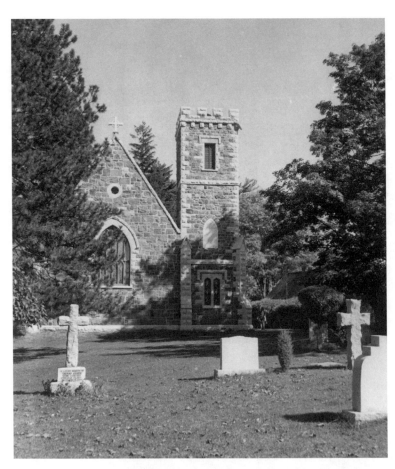

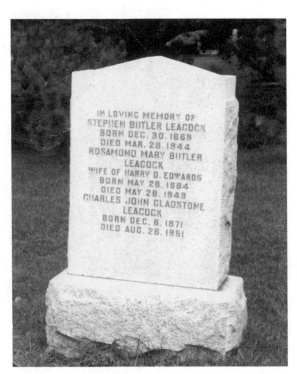

IN LOVING MEMORY OF
STEPHEN BUTLER LEACOCK
BORN DEC. 30. 1869
DIED MAR. 28. 1944
ROSAMOND MARY BUTLER
LEACOCK
WIFE OF HARRY D. EDWARDS
BORN MAY 28. 1884
DIED MAY 28. 1949
CHARLES JOHN GLADSTONE
LEACOCK
BORN DEC. 6. 1871
DIED AUG. 26. 1951

The Leacock grave marker, St. George's churchyard, Sutton, Ontario.

St. George's churchyard, Sutton. Leacock witnessed the building of this chapel in the 1870s. He shares a gravesite here with a brother and a sister.

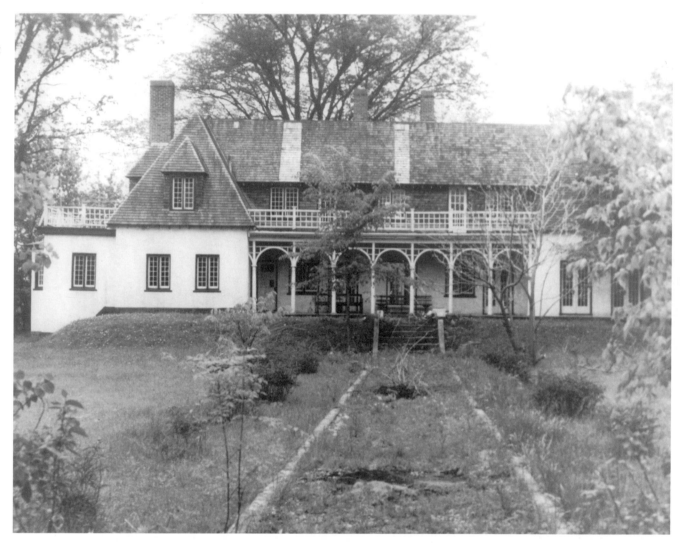

For thirteen years after his death, the Leacock summer home was abandoned to the elements, the lawns and gardens overgrown. This picture was taken in 1957, as restoration began. Note the temporary repair to the leaking roof.

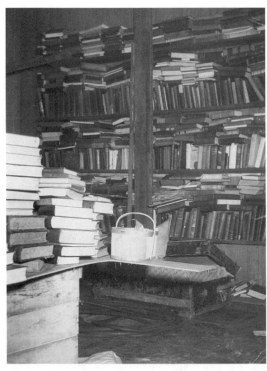

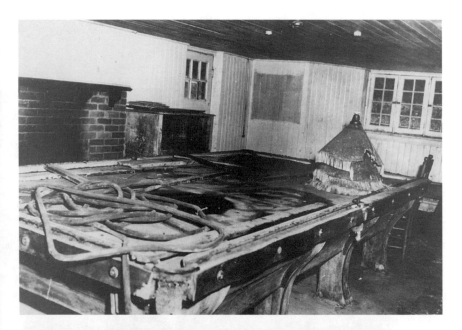

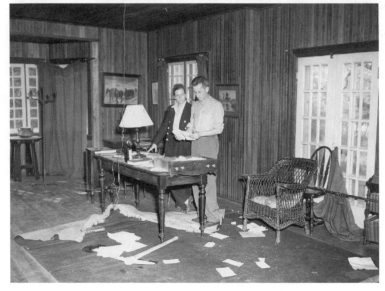

Above: Stephen Leacock's library, before restoration, 1957.

Top right: The billiard room, before restoration, 1957.

Right: Henry and Phyllis Janes, in the living room, July 1949. The Janeses obtained a lease on the home from Stephen Jr. in the summer of 1949, and expressed hopes of developing a seminar centre. Stephen Leacock Jr. vetoed the idea, and the property reverted to its former state of neglect.

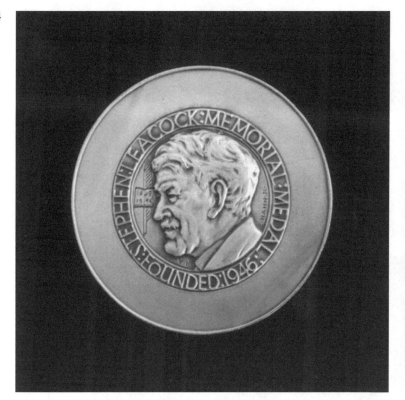

The Leacock Medal for Humour, first awarded in 1947. It was designed by Emanuel Hahn, creator of the Canadian "Bluenose" dime.

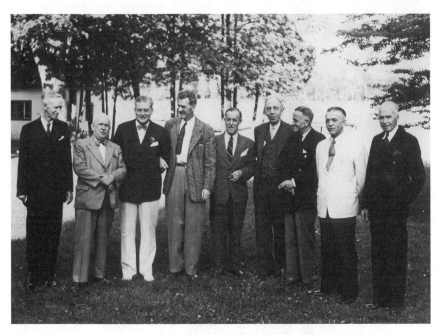

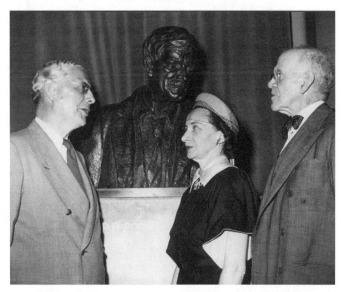

Head table guests, first Leacock Medal dinner, June 13, 1947.
Left to right: C.H. Hale, Louis Blake Duff, Paul Copeland
(chairman of Leacock Memorial Committee) William Arthur
Deacon, Harry Symons (medal winner), B.K. Sandwell,
(unknown) Mayor Mel Seymour, John Drinkwater.

Unveiling the Leacock bust, Orillia Public Library,
September 1951. Left to right: Premier Leslie
Frost, Elizabeth Wyn Wood, George Leacock.

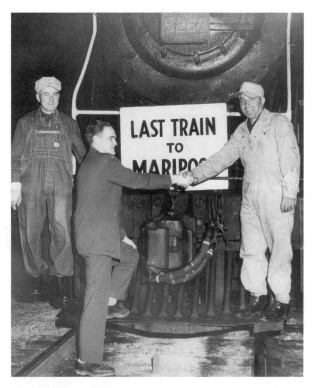

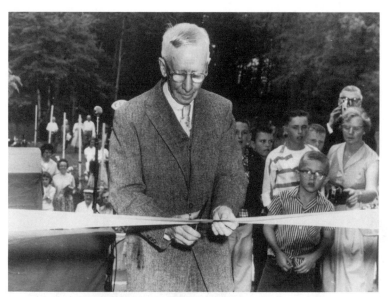

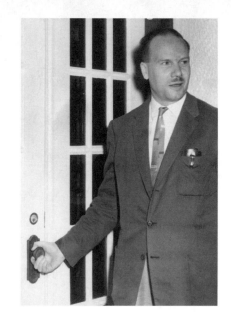

Above: Last Train to Mariposa, June 21, 1958. Pete McGarvey with engineer and trainman. The evening train had pulled into "Mariposa" (Orillia) at the same hour for almost sixty years.

Top right: C.H. Hale cuts the ribbon at the Leacock Home opening, July 5, 1958.

Right: Hon. Alvin Hamilton, Minister of Northern Affairs, opens the door at the Leacock Home, July 5, 1958. Hamilton secured a $15,000 grant for the home's restoration.

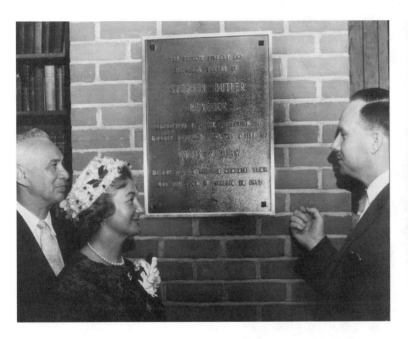

Louis and Marie Ruby, unveiling a plaque acknowledging their contribution of over 30,000 artifacts to the home.

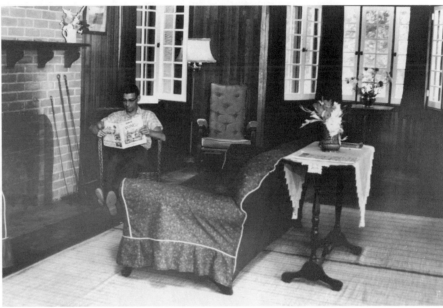

Curator Ralph Curry in the restored living room, July 1959.

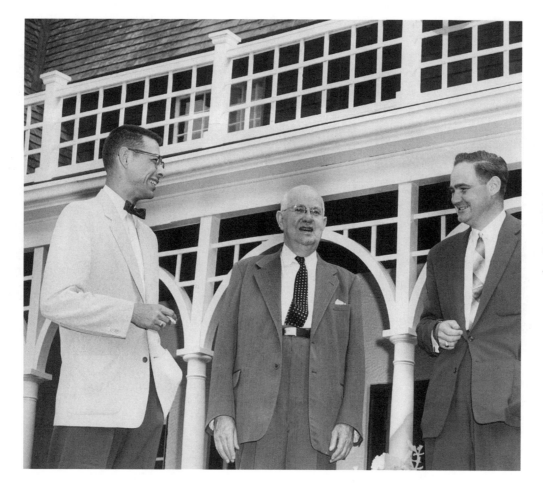

Ralph Curry (left) and
Pete McGarvey (right)
with Hon. Patrick Kerwin,
Chief Justice of Canada,
July 1959.

Top: Entrance to the
Stephen Leacock
Memorial Home, 1958.

Right: Ralph Curry with
visitors at Leacock's home-
made writing desk, on the
sunporch, 1968.

Far right: Ralph Curry at
the same desk, 1983. As
the years passed, the cura-
tor came more and more to
resemble Leacock.

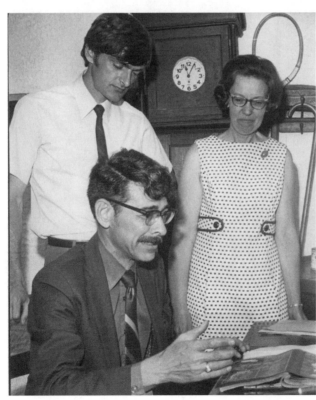

Ralph Curry (second row, second from right) with guides, 1959.

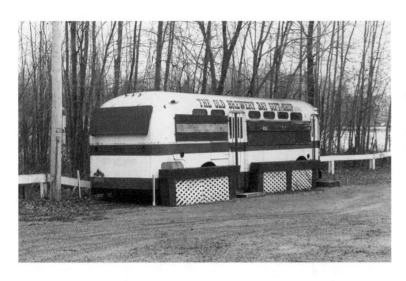

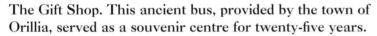

The Gift Shop. This ancient bus, provided by the town of Orillia, served as a souvenir centre for twenty-five years.

John Drainie, as Stephen Leacock, at the writing table on the sunporch, June 1960. Canada's foremost character actor portrayed Stephen Leacock on stage, radio, and television for many years.

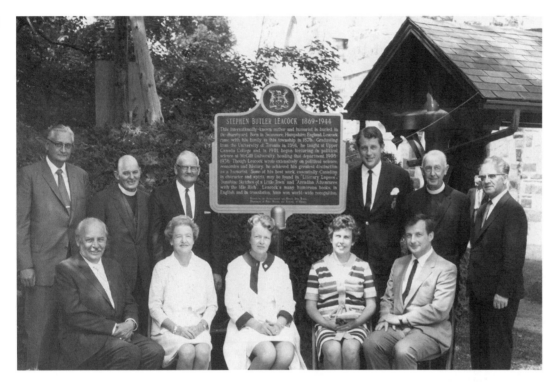

Unveiling an Ontario historic plaque at St. George's churchyard, Sutton, 1970.

Leacock sketch by Orillia artist Carl Jensen, 1959.

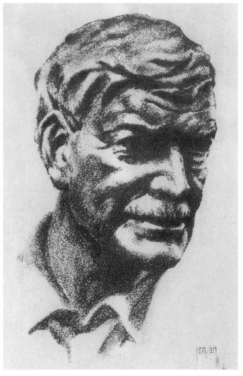

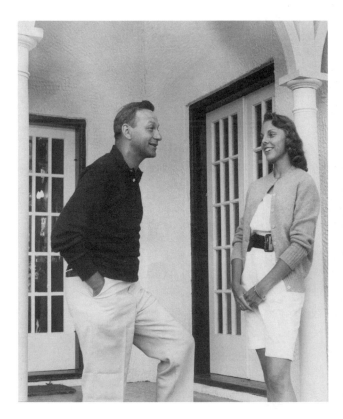

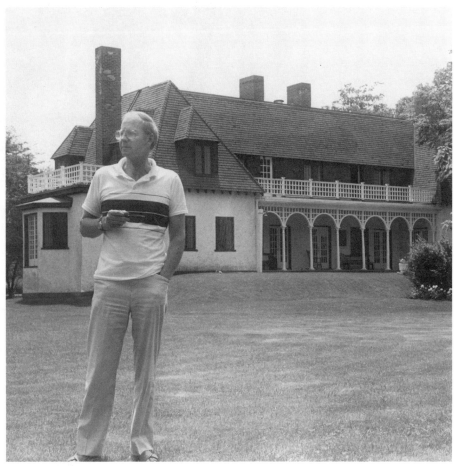

Above: Comedian Frank Schuster with guide, July 1958. Schuster, a Leacock admirer, was among the first visitors after the opening of the home.

Right: Curator Jay Cody on the lawn, 1980.

84

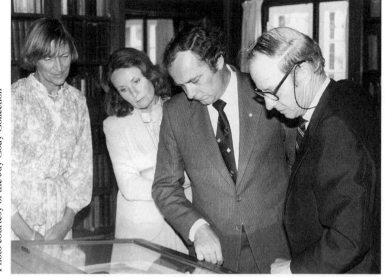

Top: Curator Jay Cody with Governor General Edward Schreyer, August 1980

Far right: Prime Minister Jean Chrétien, near the sunporch, 1993.

Right: Prime Minister Kim Campbell with curator Daphne Mainprize, 1993.

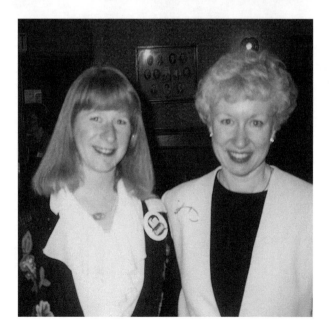

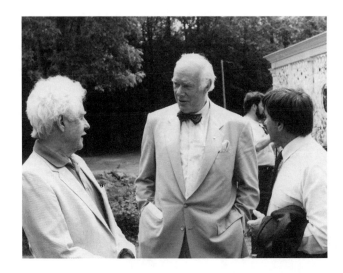

Leacock Medal winners W.O. Mitchell (left) and Pierre Berton (centre) with cartoonist Ben Wicks at The Old Brewery Bay, June 1990.

Christmas sleigh ride, The Old Brewery Bay, 1990. Seated (right) in the sleigh is Jean Dickson, for many years chair of the Winner Selection committee, Stephen Leacock Associates.

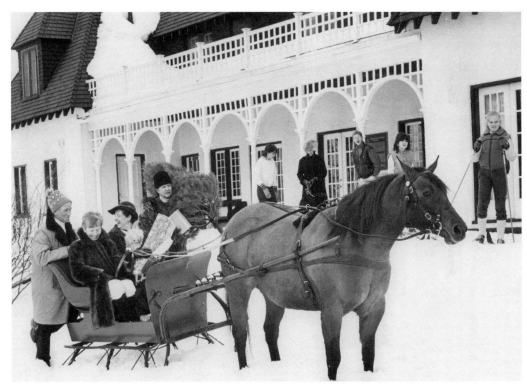

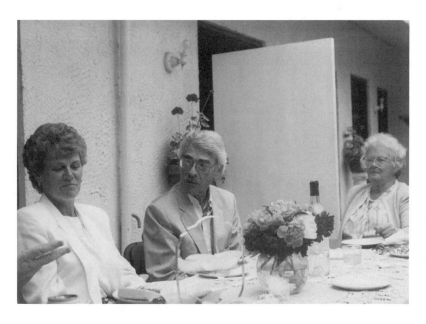

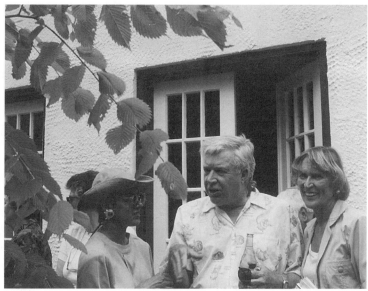

Author Timothy Findley, honoured by Writers Development Trust at The Old Brewery Bay, July 1995.

Ralph Curry (centre) with Barbara Nimmo on her last visit to The Old Brewery Bay, July 1992. For many years Stephen Leacock's niece and secretary worked with Curry to identify Leacock materials. They remained close friends until her death in June 1993.

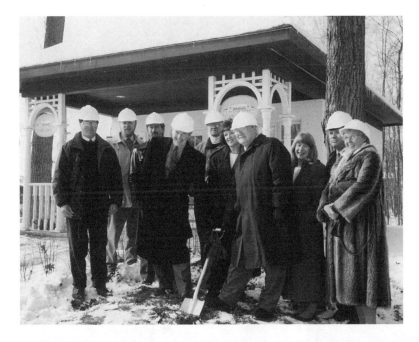

Ground breaking
for Swanmore Hall,
October 1993.

Swanmore Hall.

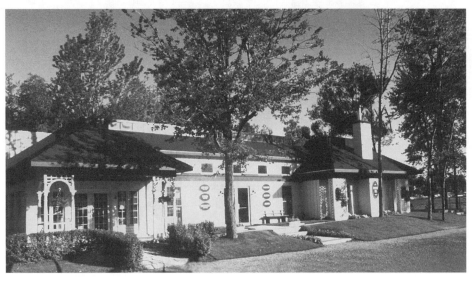

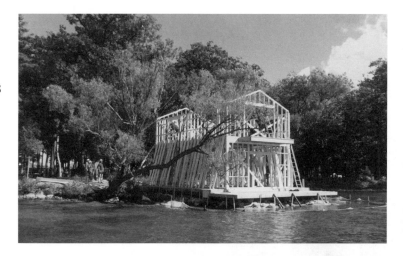

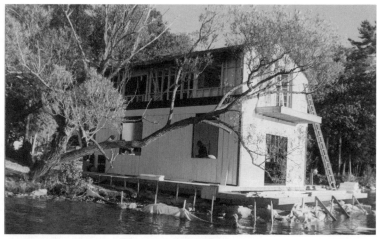

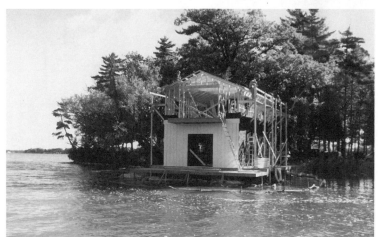

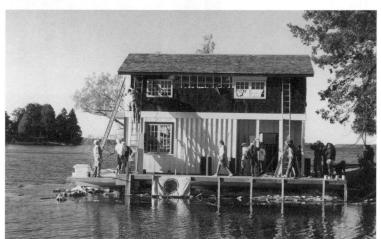

The Leacock boathouse, reconstructed in less than forty-eight hours, September 16–17, 1995.

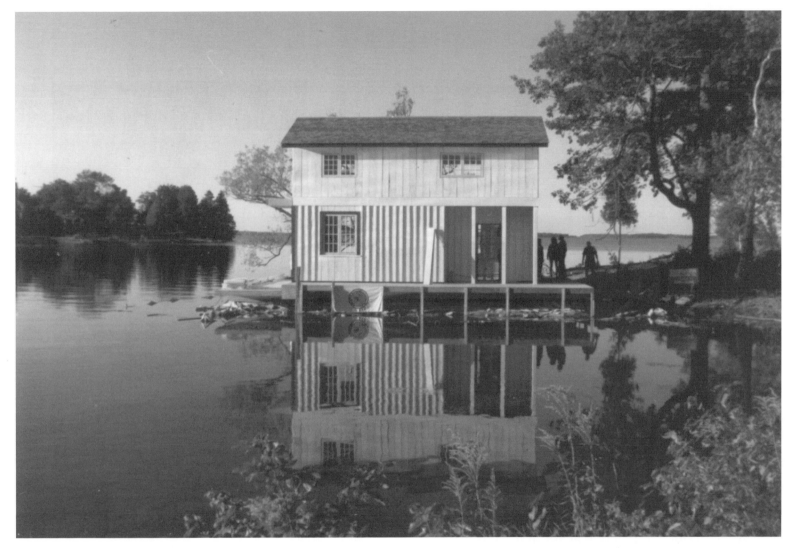

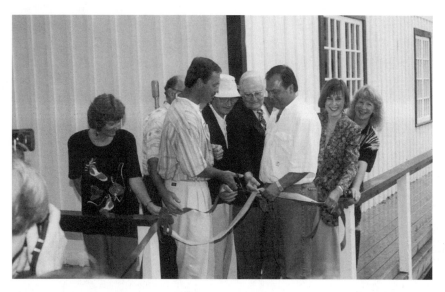

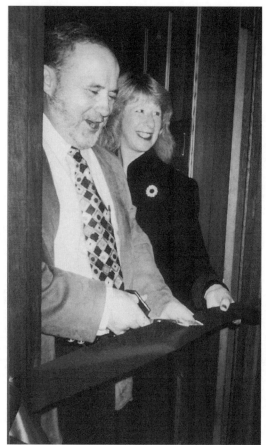

Above: Ribbon-cutting at the boathouse, September 9, 1996. Front row, left to right: Gwen Richardson, board chair, Jim Dykes, Jim Storey (holding ribbon). Back row, Wes Trinier, past board chair, Jay Cody, Pete McGarvey, Hon. Julie Munro, provincial culture minister, curator Daphne Mainprize.

Right: Cutting the ribbon, CNIB Room, Leacock home, October 22, 1996. Dr. Euclid Herie, CEO of the Canadian National Institute for the Blind and president of the World Blind Union, is joined by Daphne Mainprize at the doorway. The room contains a wide selection of Leacock books in braille.

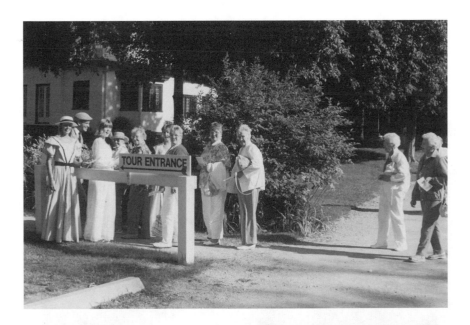

Visitors entering the pathway to the home, 1996.

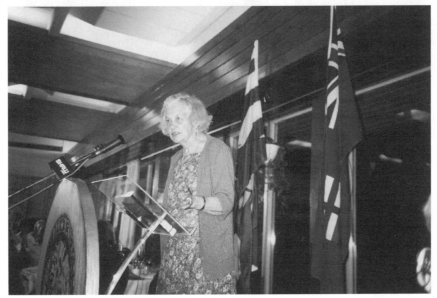

Author Elizabeth Kimball, Stephen Leacock's niece, reminisces at the fiftieth annual Leacock Medal Dinner, June 1997. The only Leacock descendant to pursue a writing career, she returns yearly to The Old Brewery Bay to conduct special tours.

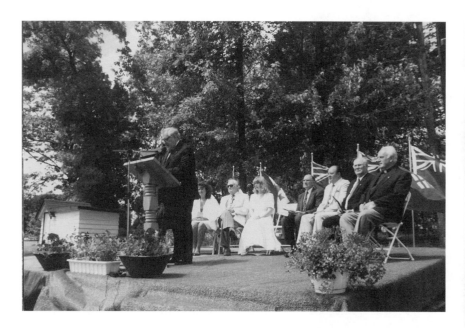

The Leacock Museum is declared a National Historic Site, June 1994. Dr. Tom Symons, chair of the National Historic Sites and Monuments Board, is at the microphone.

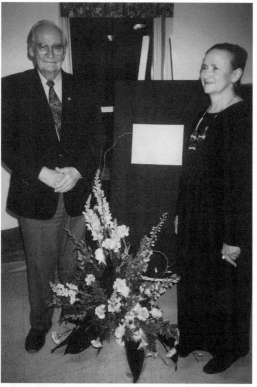

Memorial service for Ralph Curry, 28 October, 1997. Board Chair Pete McGarvey with Dr. Gwen Curry.

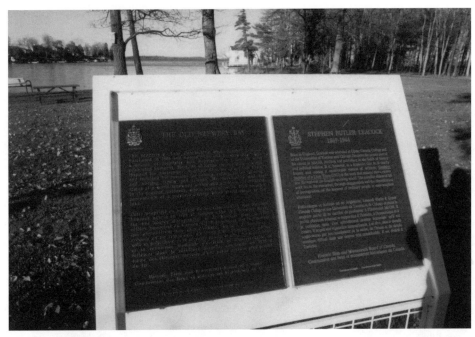

Twin National Historic Site markers at the Leacock Museum — a rarity — honour both the humorist and his summer estate. The first marker reads, "This property on the Lake Couchiching Shore, purchased by Stephen Leacock in 1908 and named 'The Old Brewery Bay,' was a source of creativity and happiness for Canada's most celebrated humorist. Here he absorbed the impressions that inspired his masterpiece, *Sunshine Sketches of a Little Town*, and indulged his passions for fishing, sailing, mixed farming, and family and friends."

Photo by Julie Langpeter

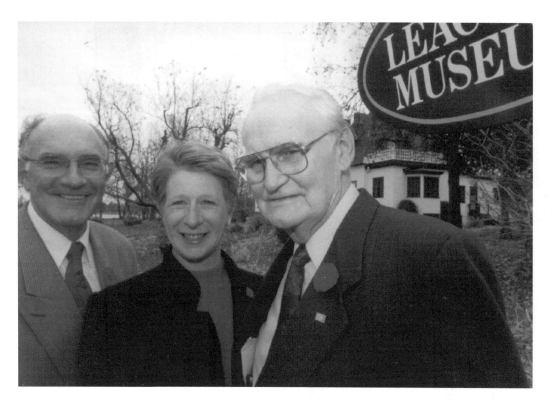

On November 2, 1998, Ottawa announced a $666,000 Millennium Partnership Grant towards the $2-million restoration program at the Leacock Museum.

Left to right: Paul Devillers, MP, Simcoe North, Daphne Mainprize, Director/Curator, Pete McGarvey, Leacock Museum Board Chairman. The following week additional federal support for the museum was announced by Andy Mitchell, Minister of State responsible for Parks Canada.

Photo by Julie Langpeter

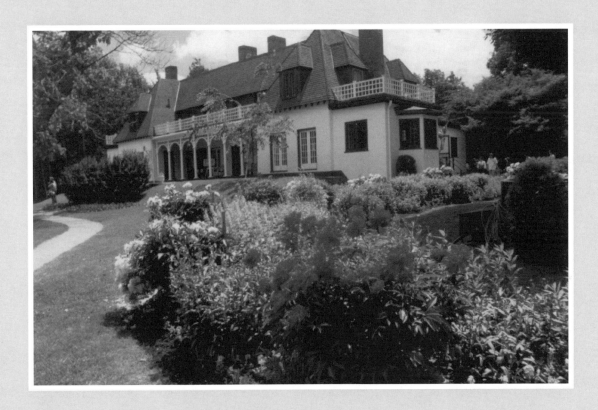

The Old Brewery Bay today.